Animal Dreams
Coloring Book
BY ALLISON GEE

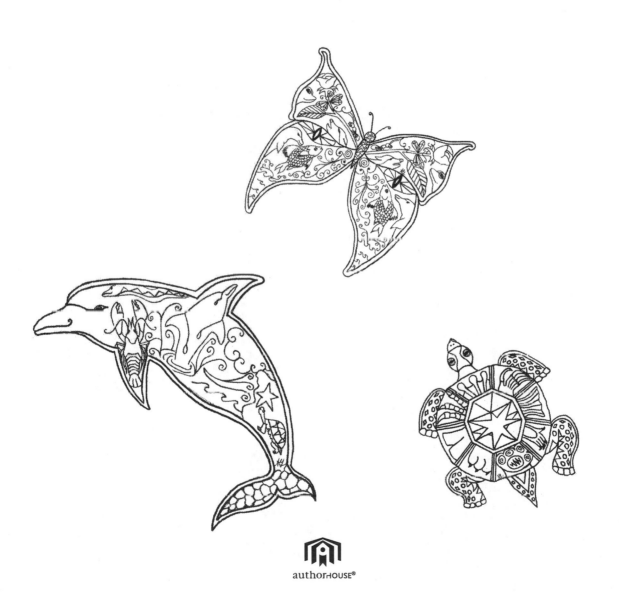

authorHOUSE®

AuthorHouse™
1663 Liberty Drive
Bloomington, IN 47403
www.authorhouse.com
Phone: 1-800-839-8640

First published by AuthorHouse 6/24/2009

ISBN: 978-1-4389-9014-9 (sc)

Printed in the United States of America
Bloomington, Indiana

This book is printed on acid-free paper.

Inside this coloring book are unique images of cute, happy animals. Drawn inside the animals are images of what the animal might dream about.

Animals In This Coloring Book

{Animals in the book are in alphabetical order.}

Anteater	Eagle	Panda
Armadillo	Elephant	Parrot
Bat	Frog	Penguin
Bear	Goldfish	Raccoon
Beaver	Horse	Rabbit
Bee	Iguana	Ram
Beetle	Jellyfish	Rhino
Boar	Koala	Seahorse
Buffalo	Lemur	Sea Lion
Butterfly	Lion	Sheep
Camel	Manta Ray	Sloth
Cat	Mouse	Spider
Chimp	Octopus	Squirrel
Crab	Owl	Tiger
Dog		Turtle
Dolphin		Wolf

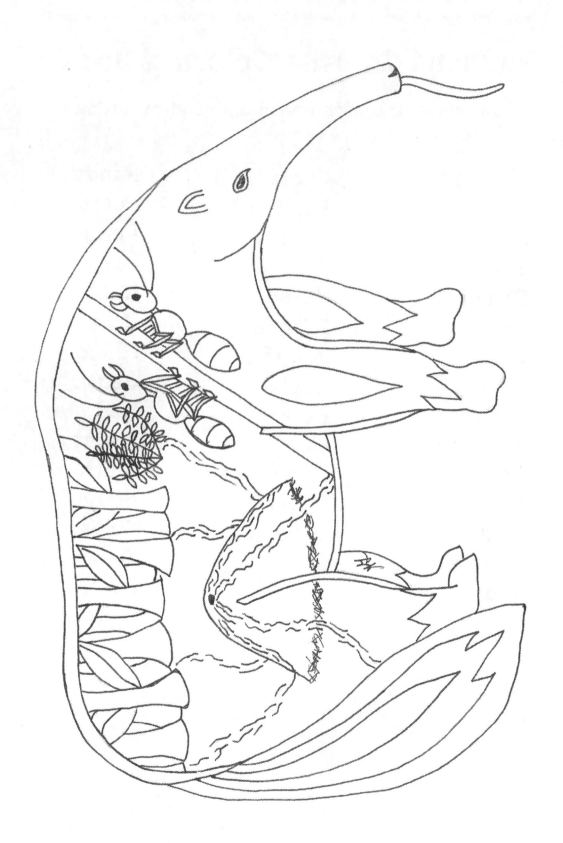

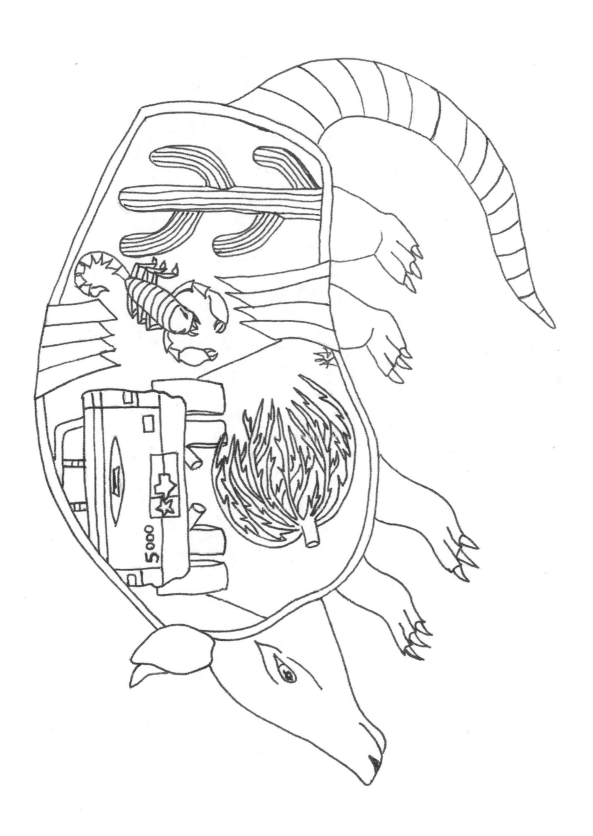

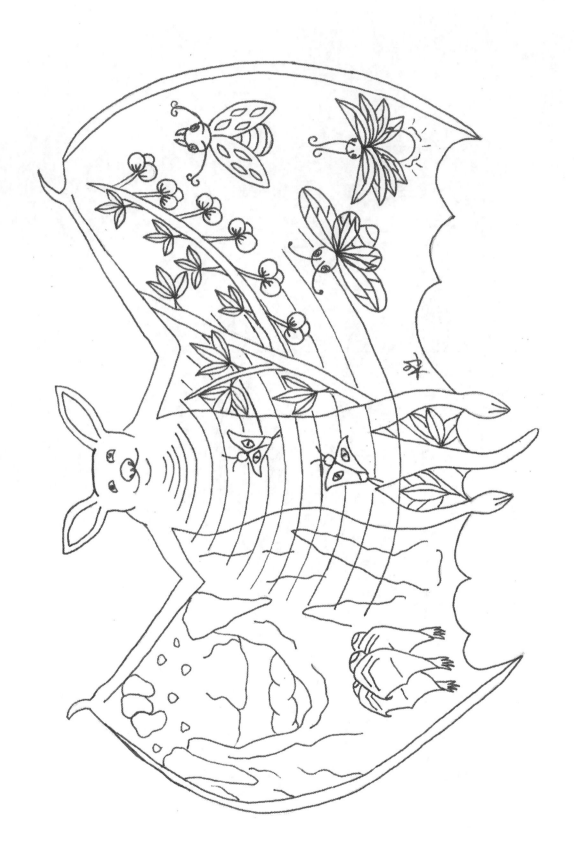

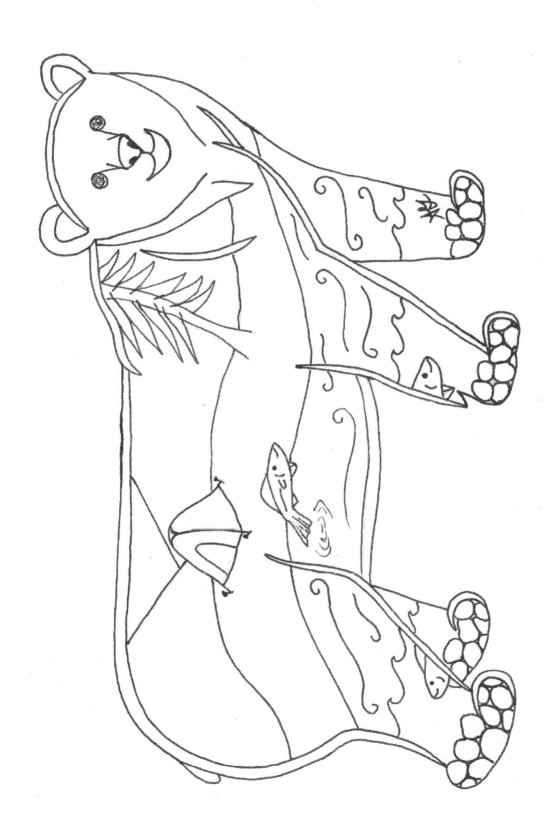

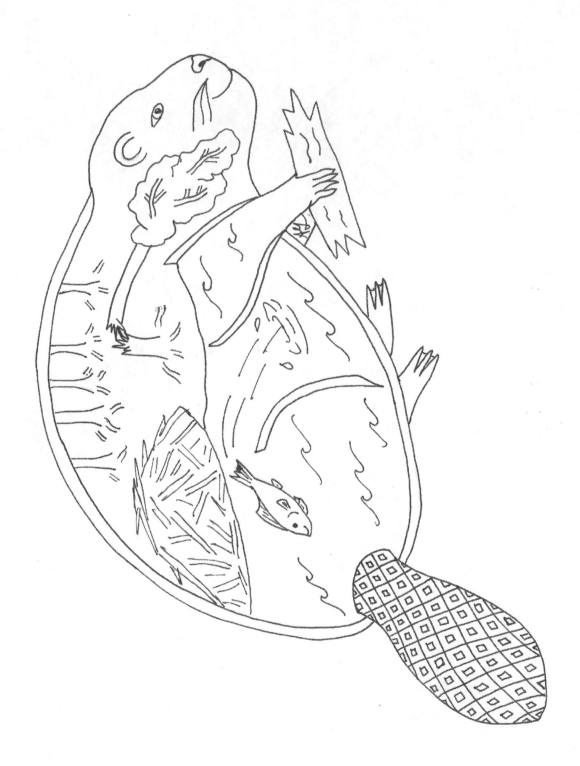

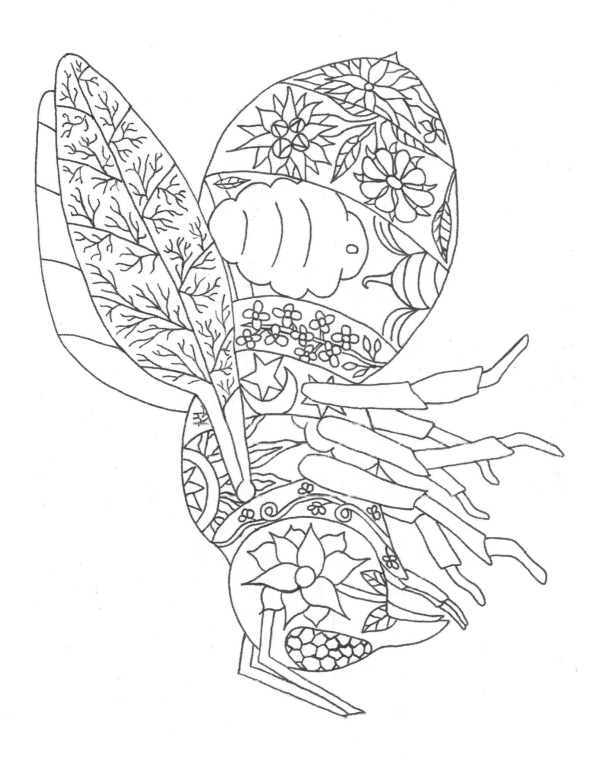

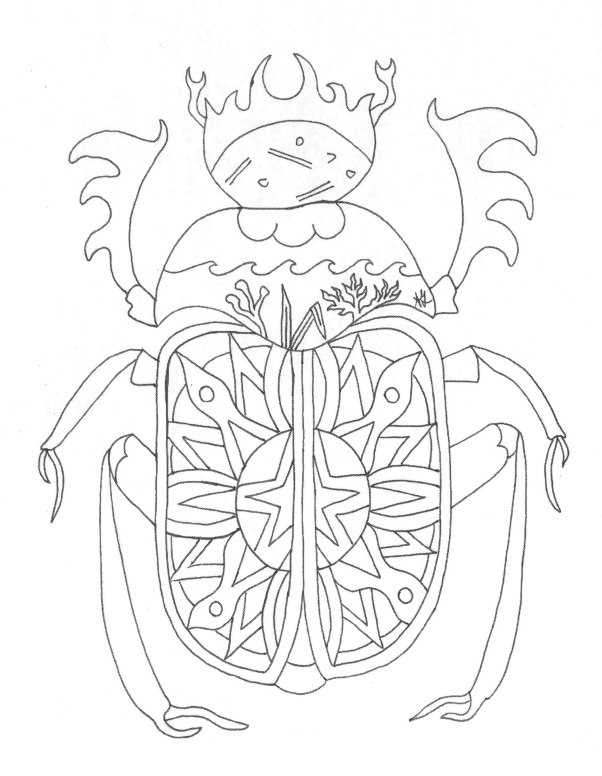

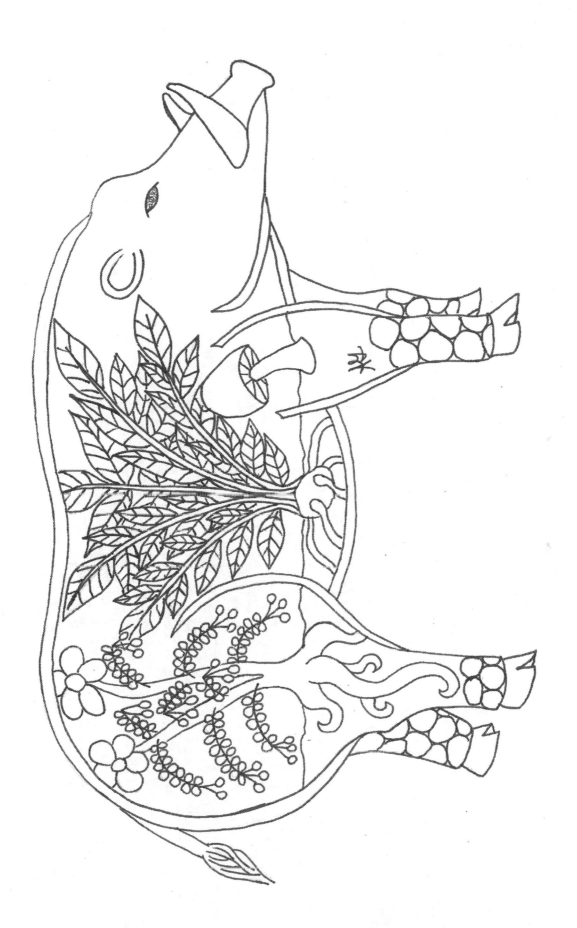

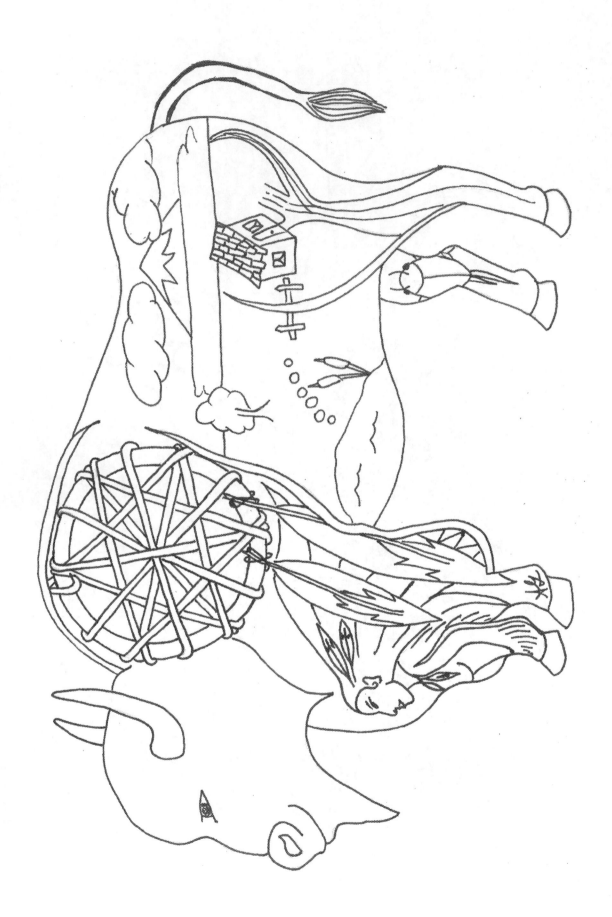

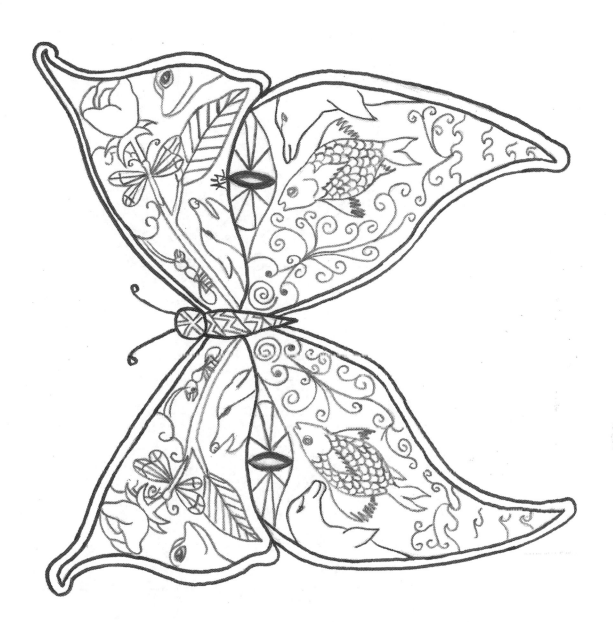

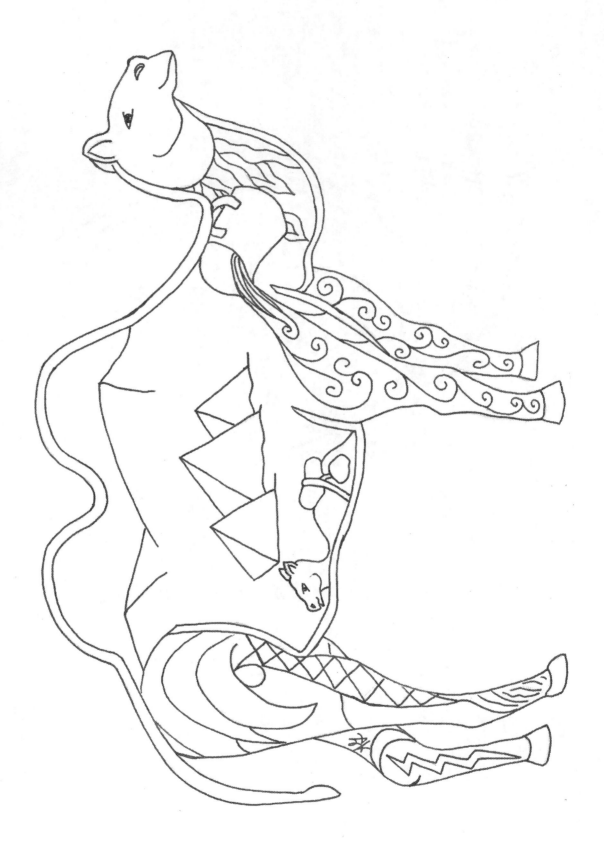

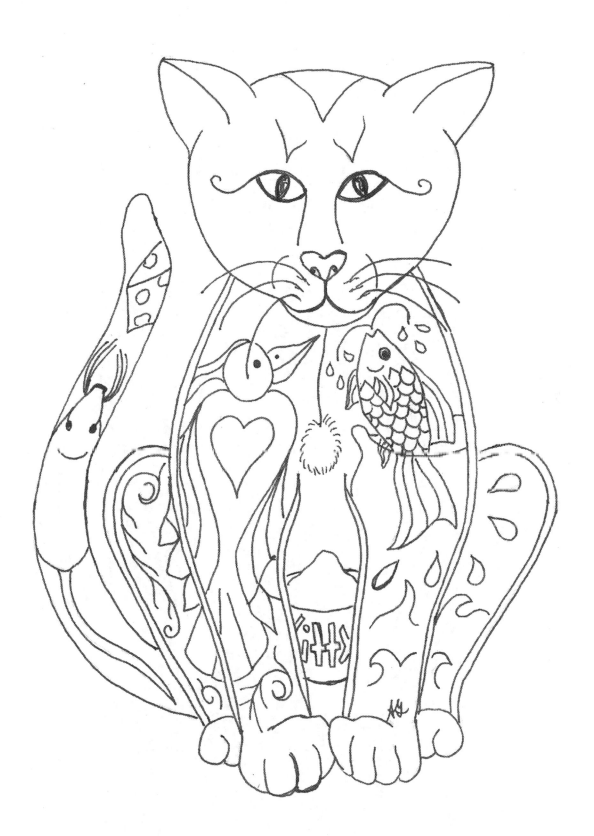

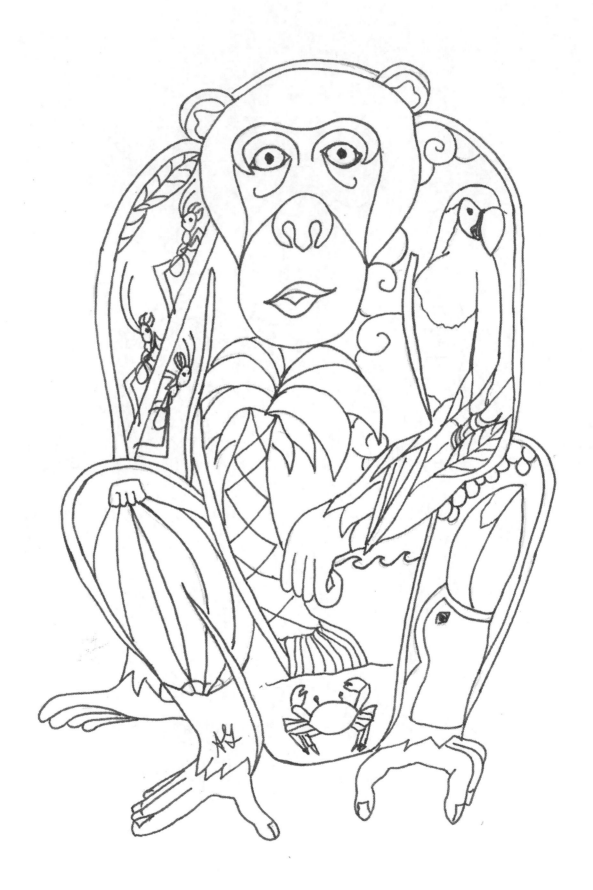

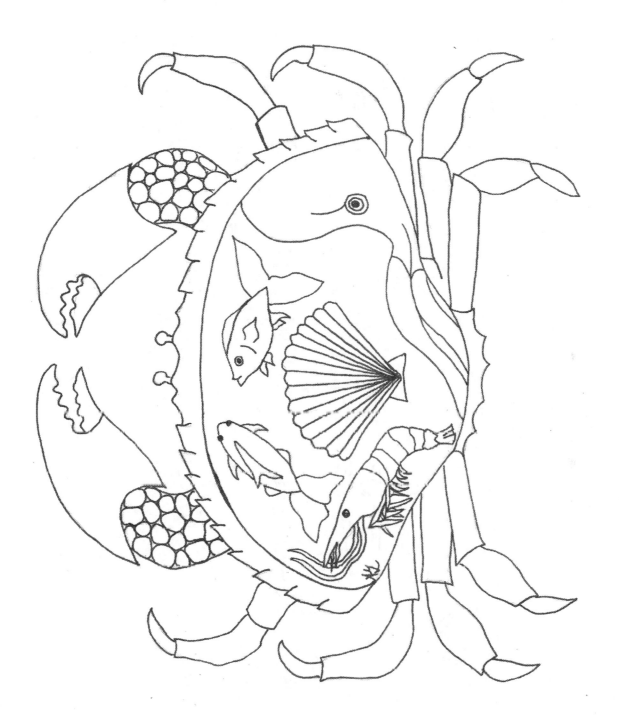

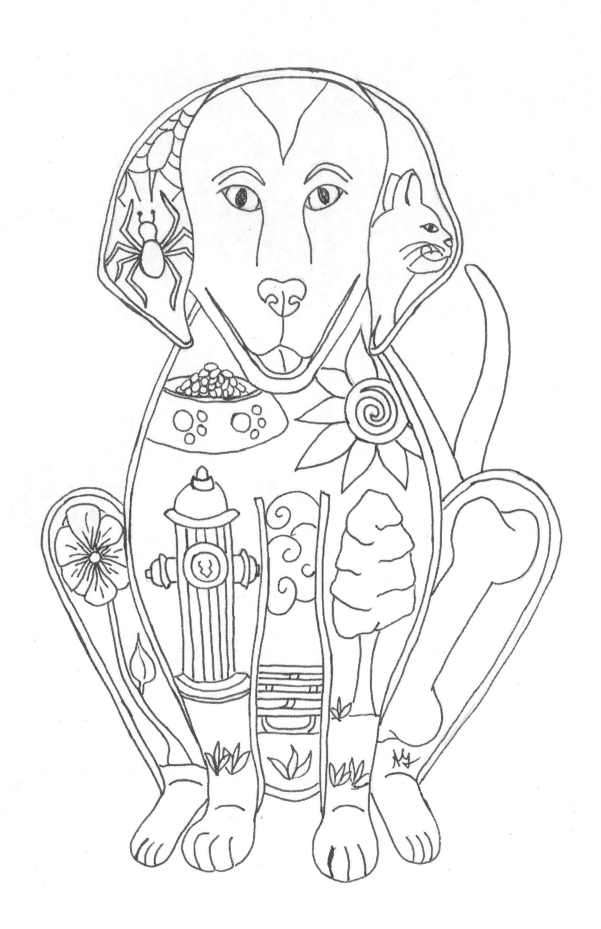

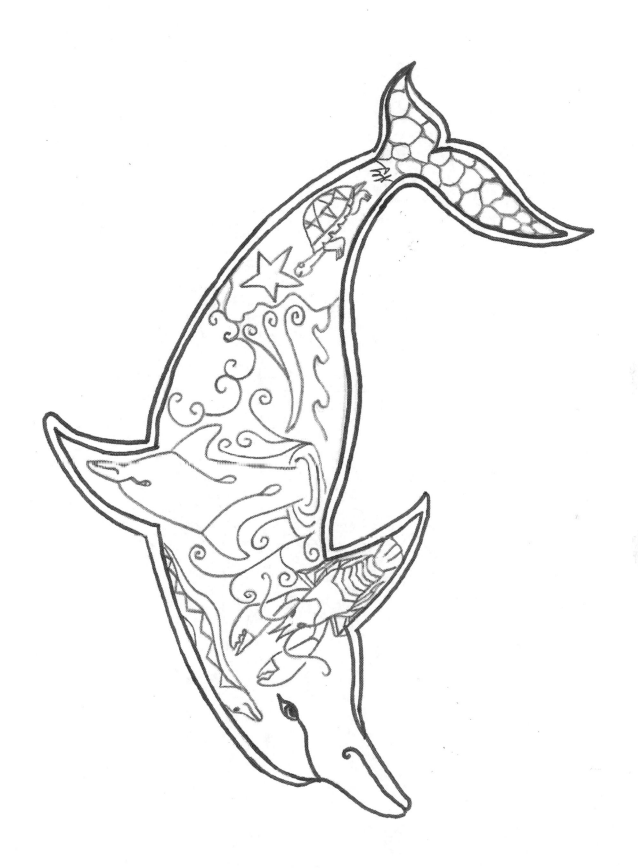

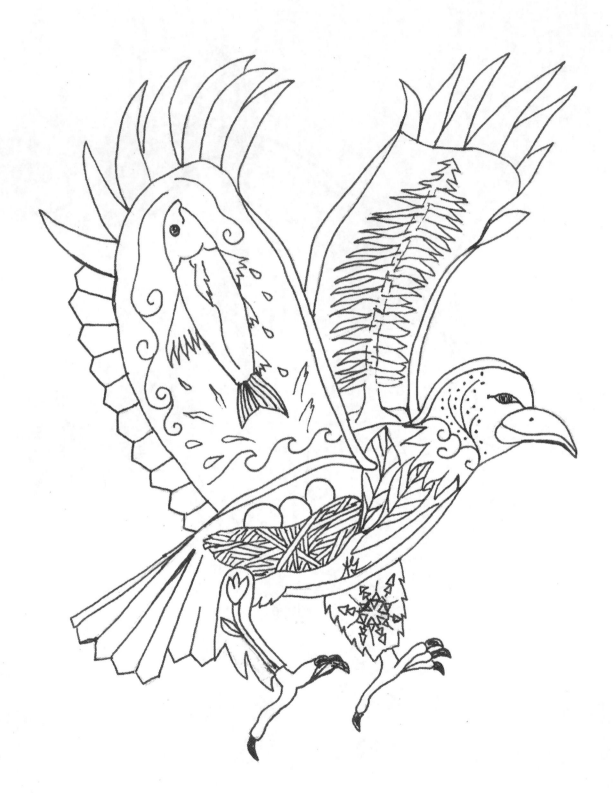

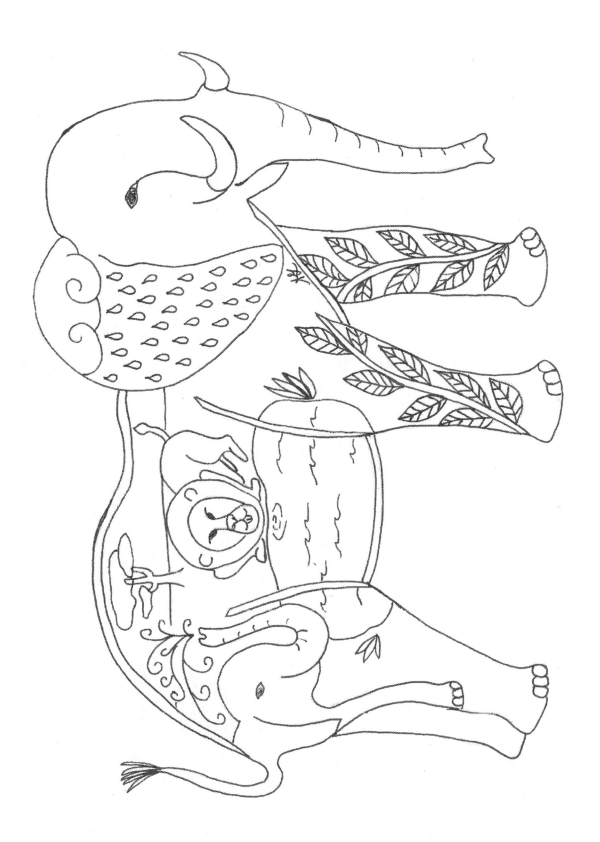

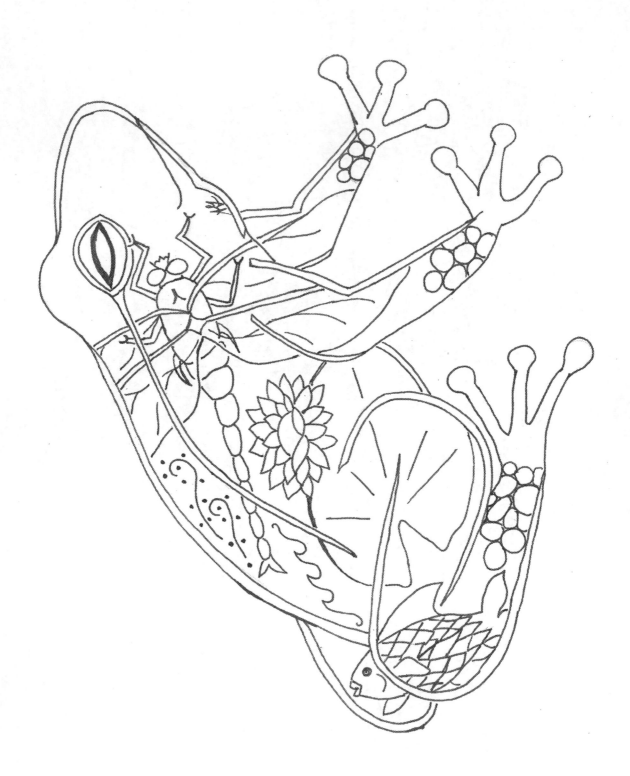

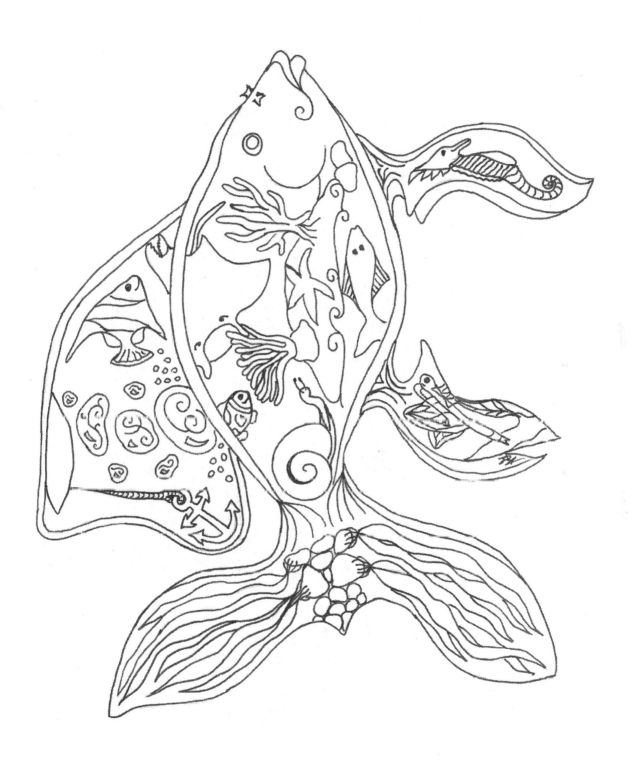

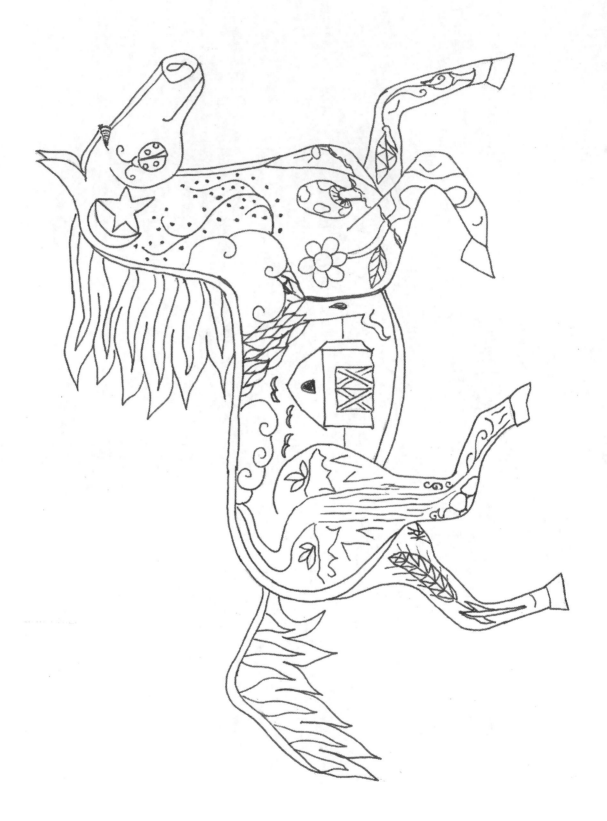

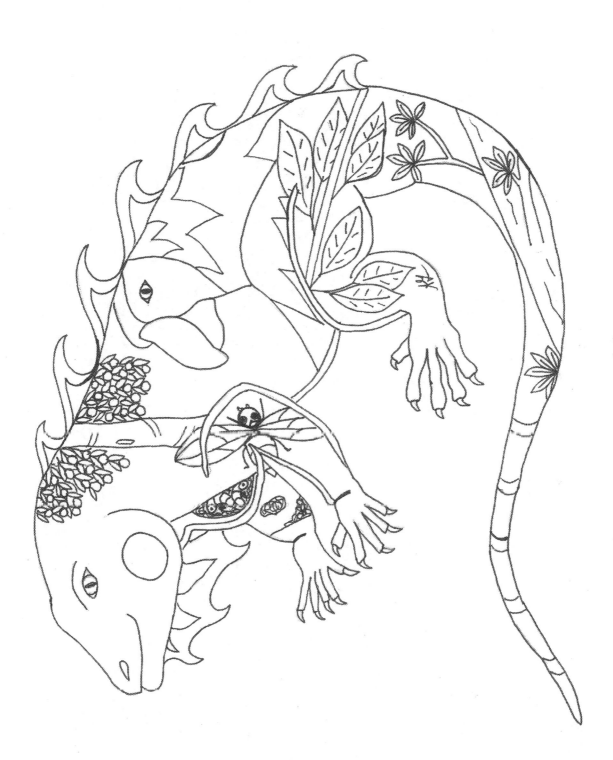

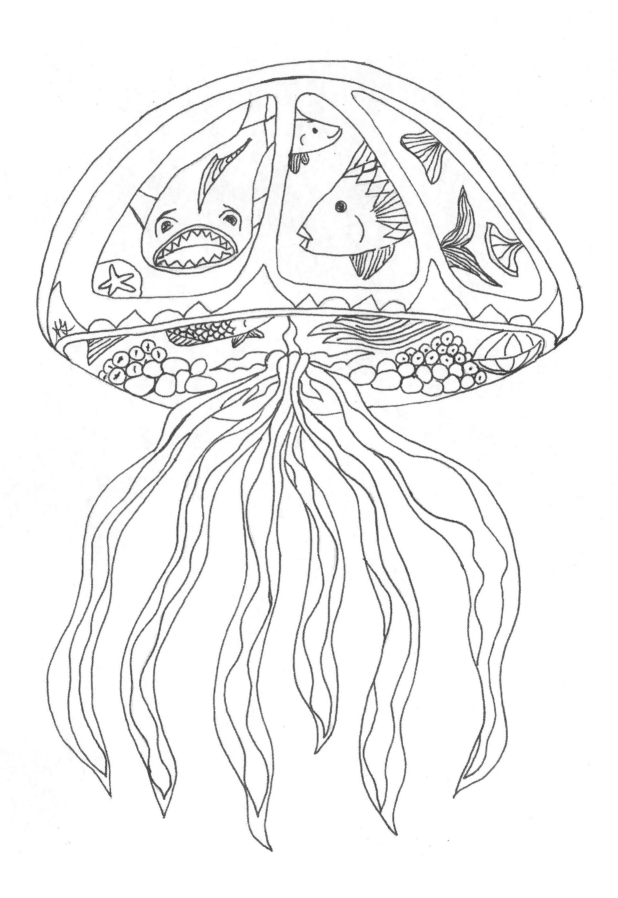

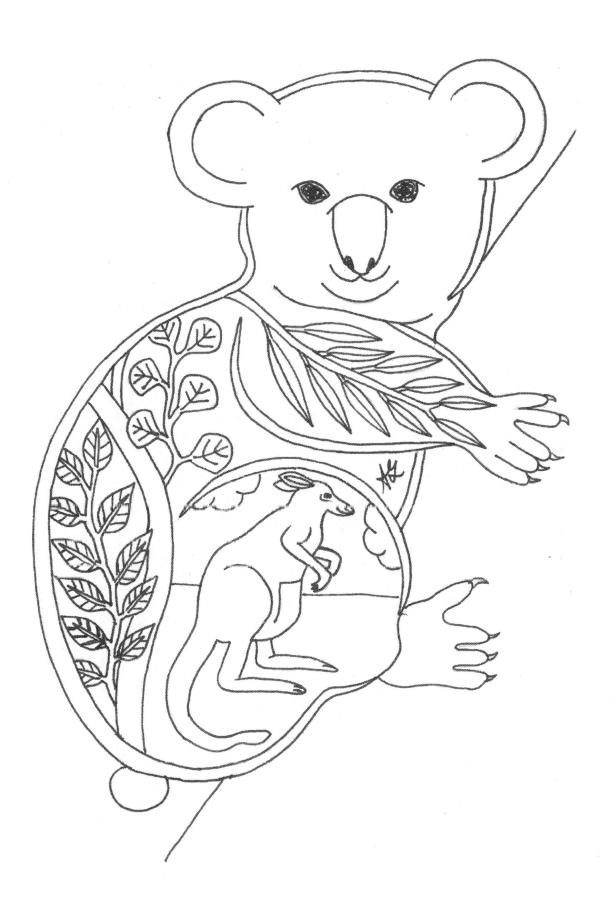

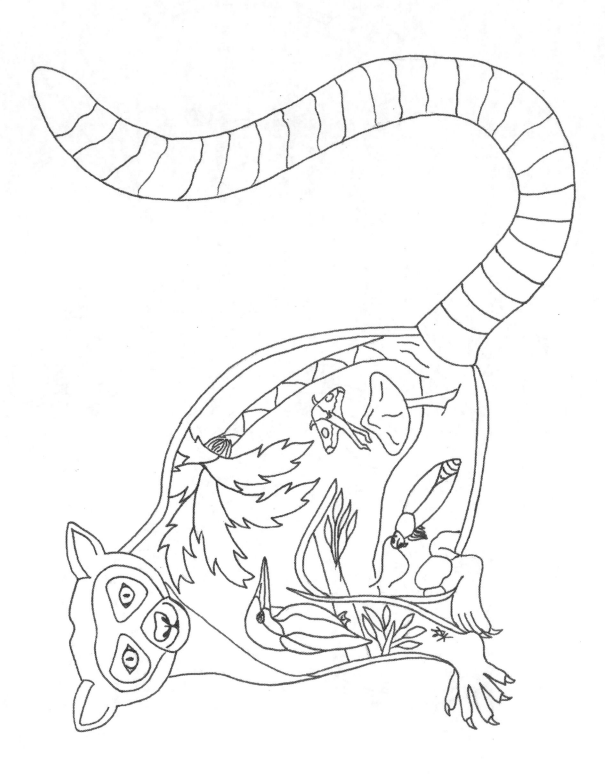

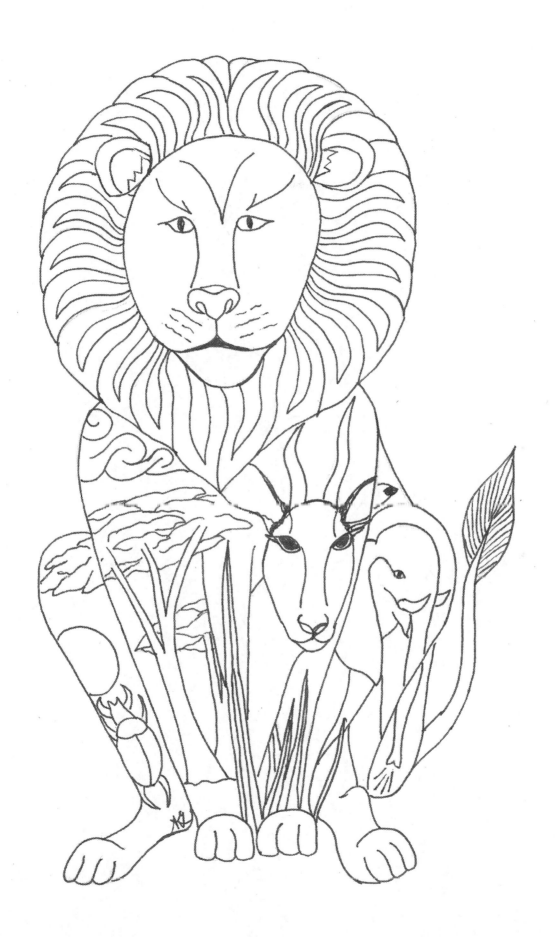

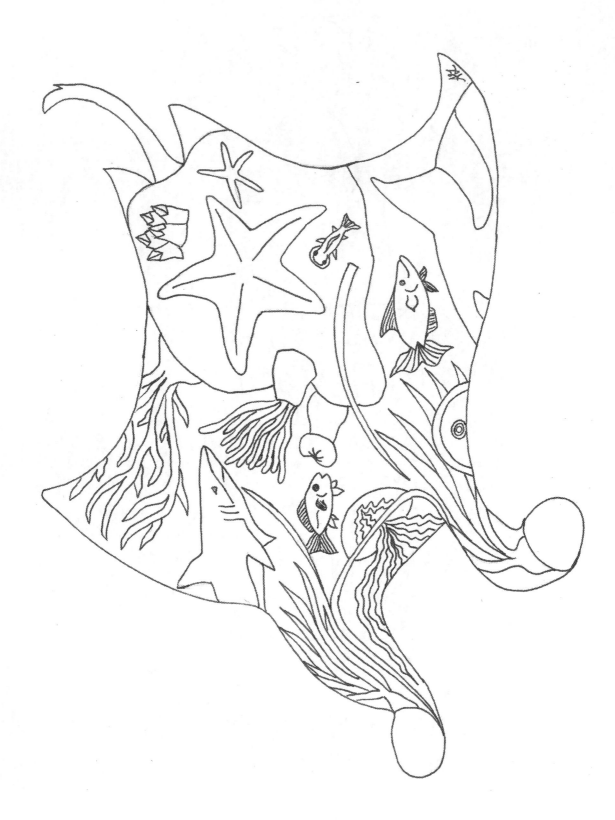

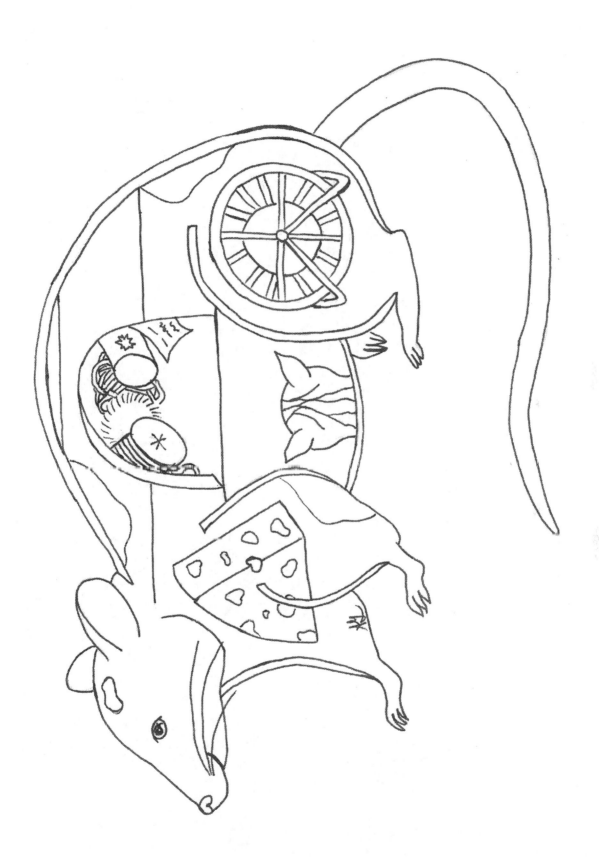

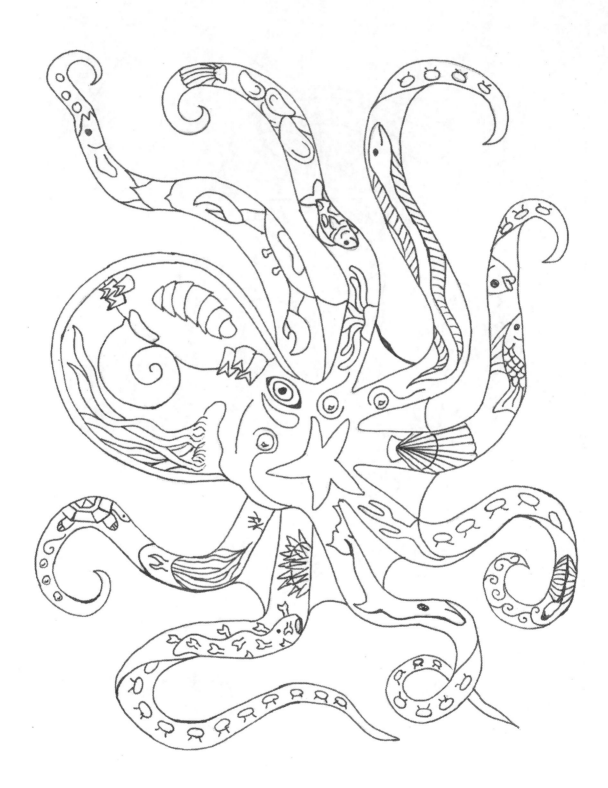

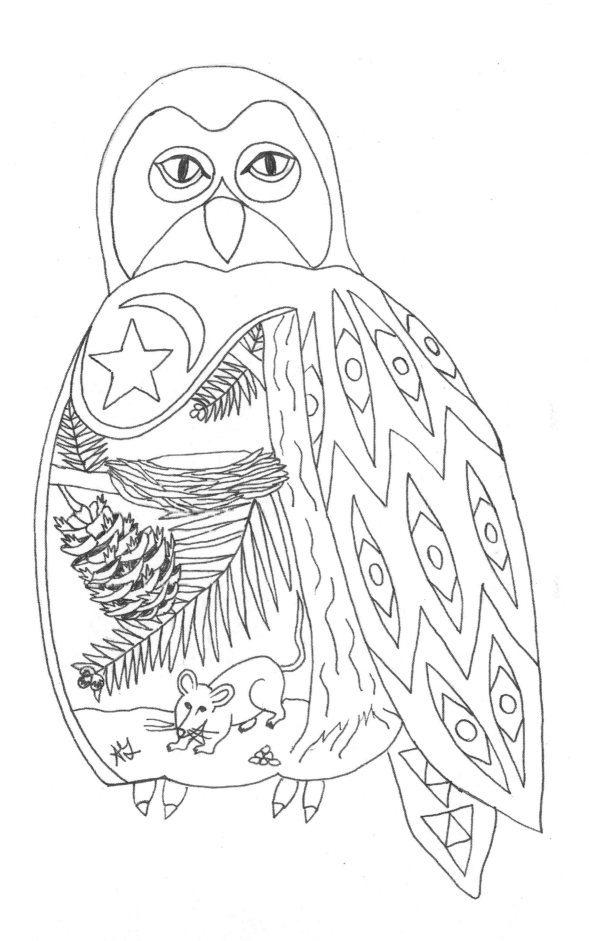

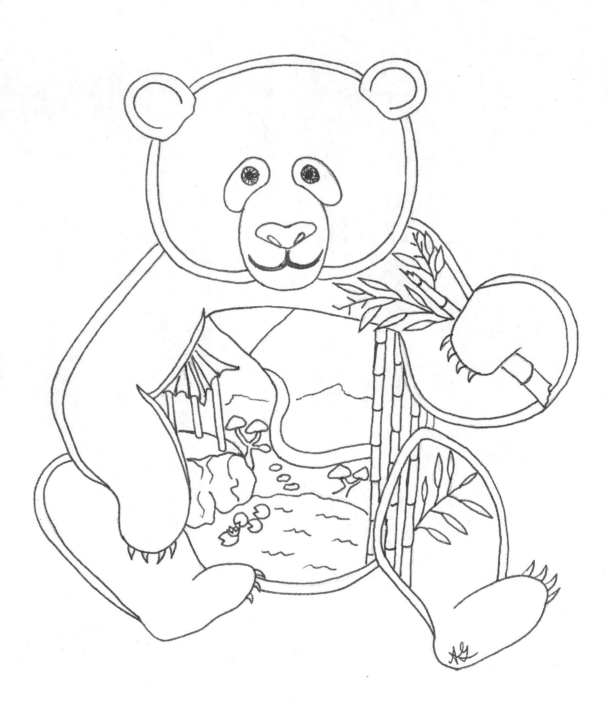

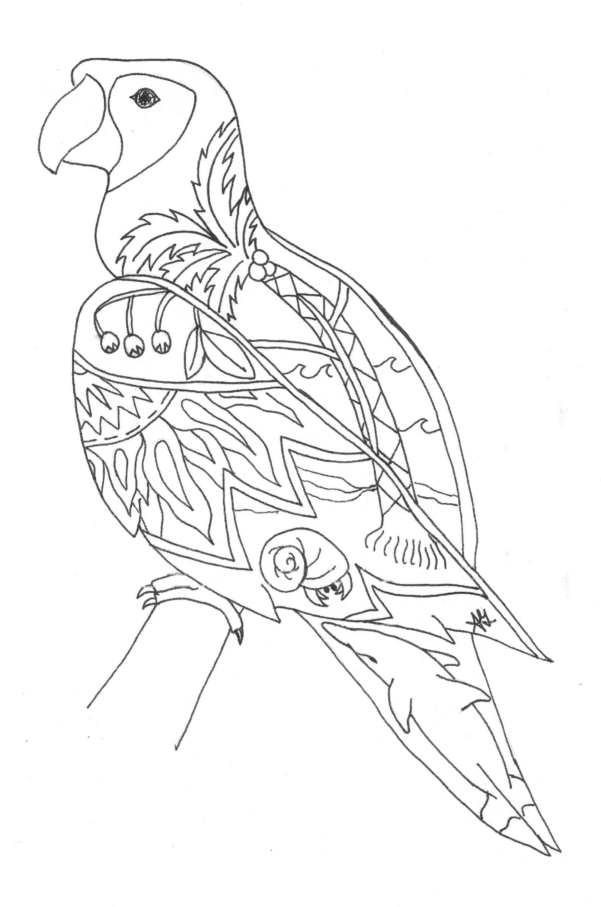

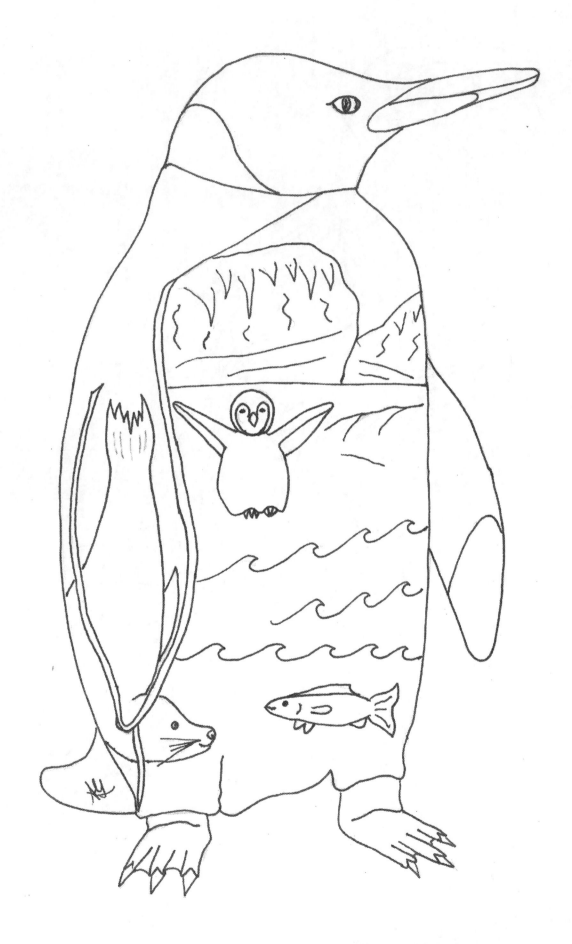

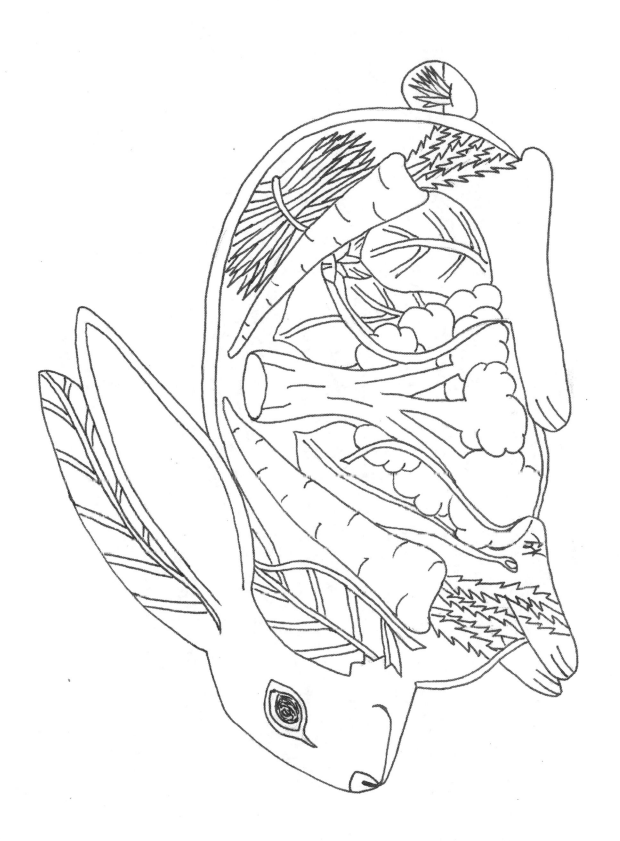

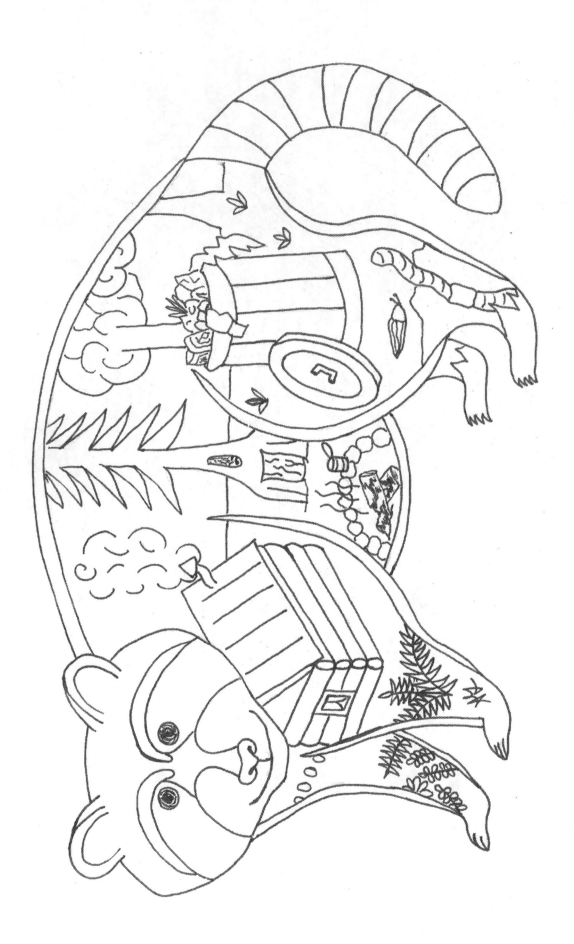

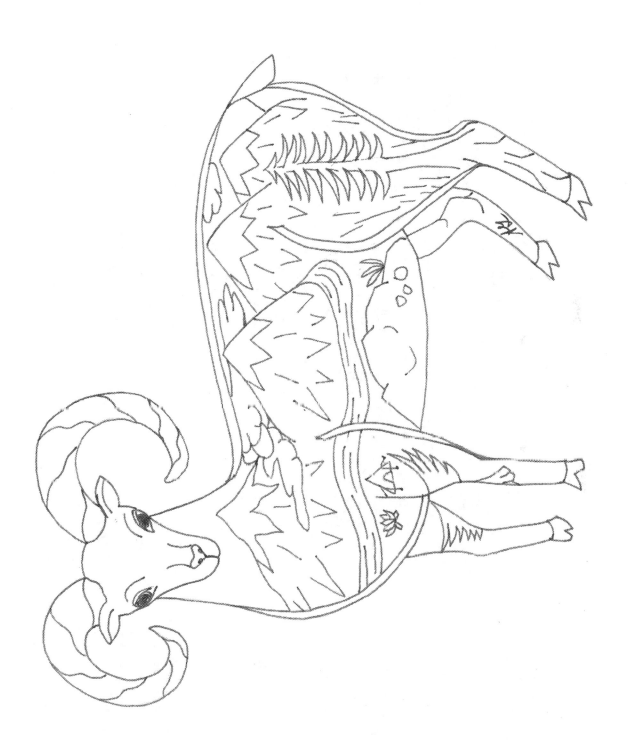

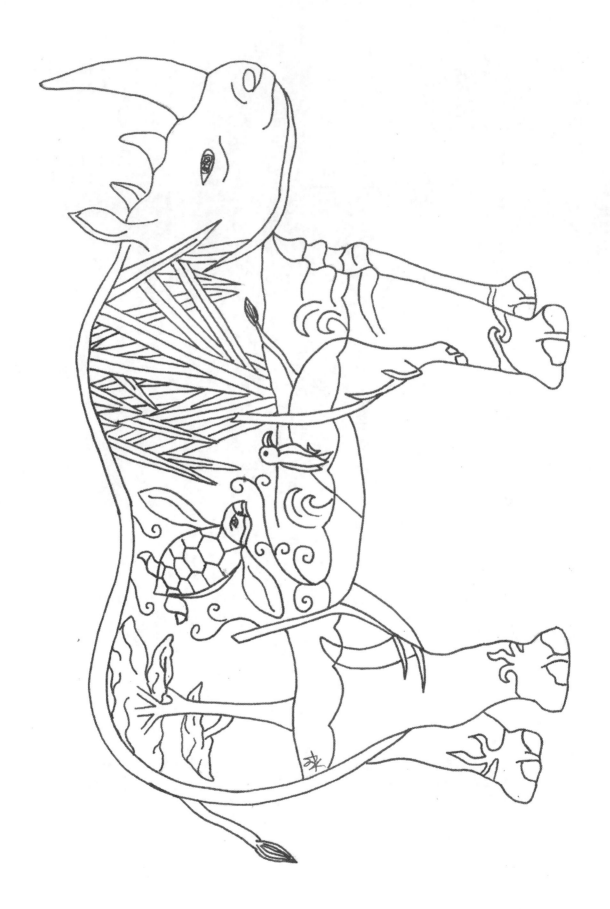

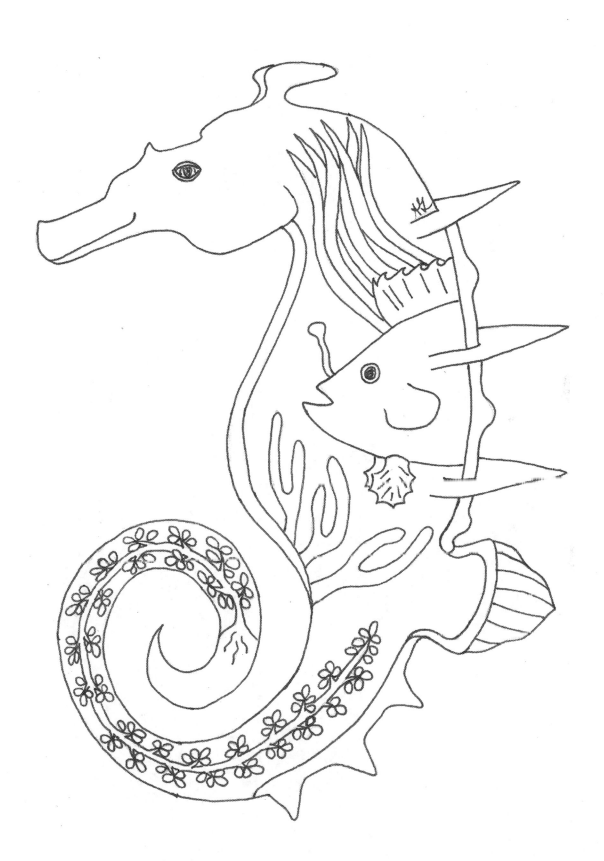

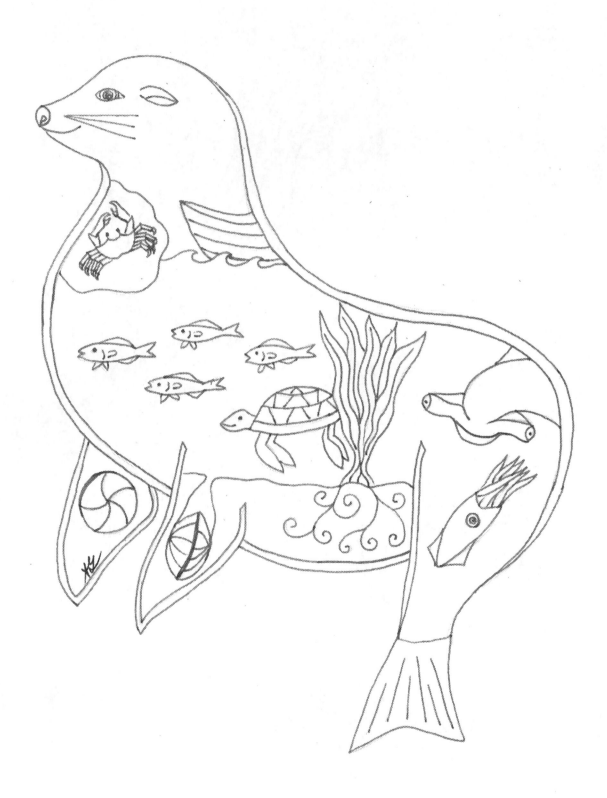

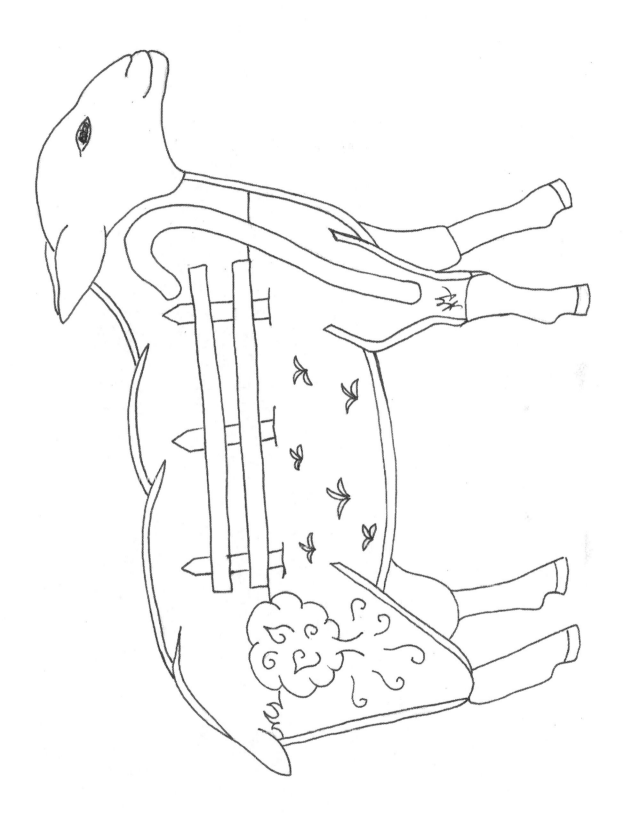

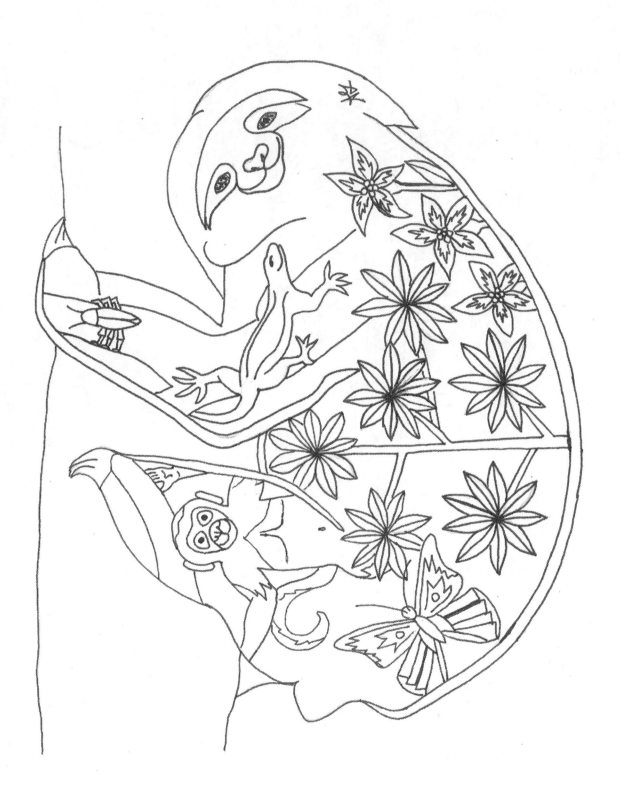

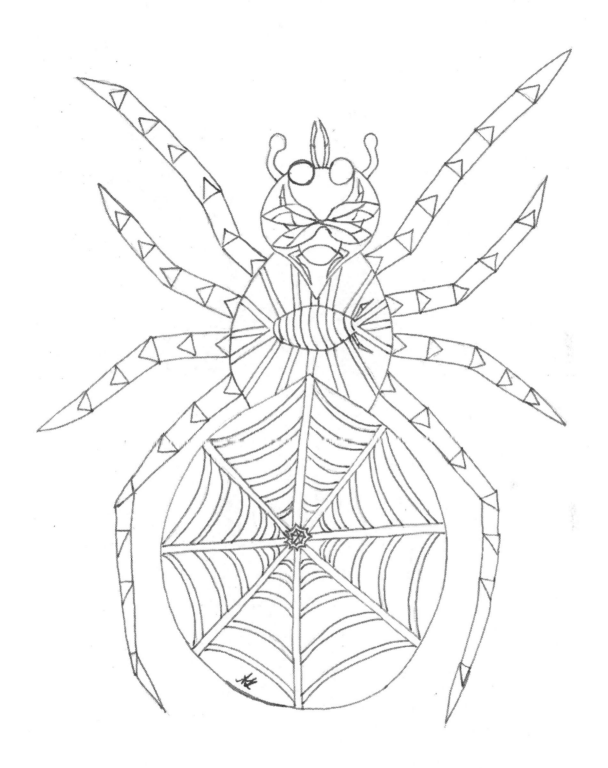

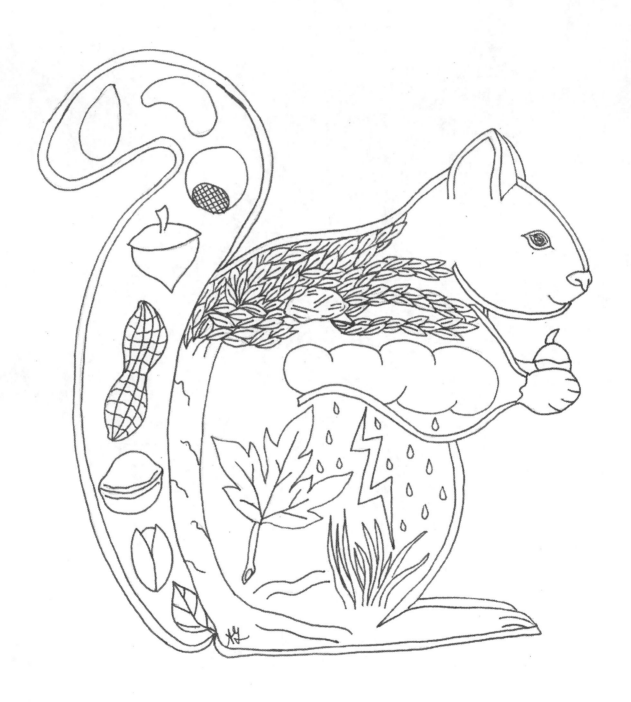

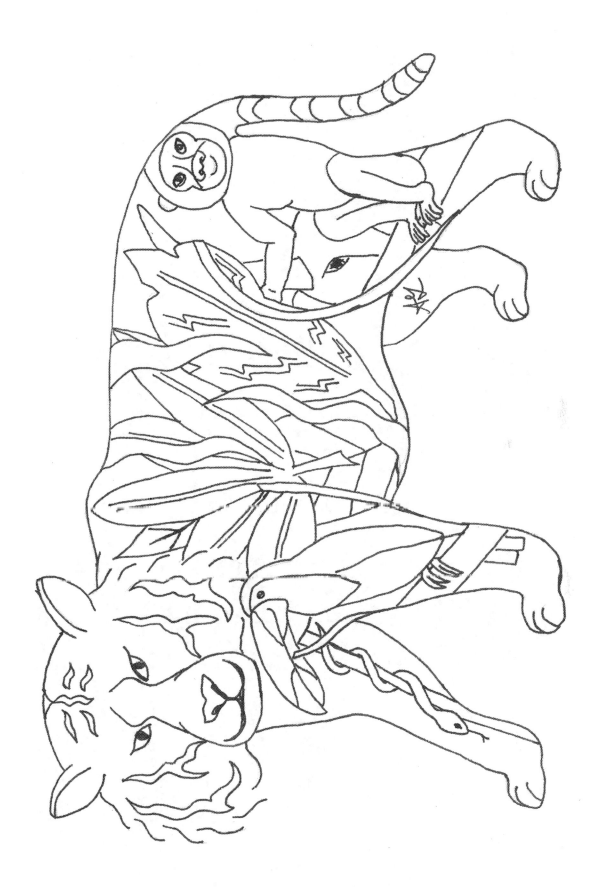

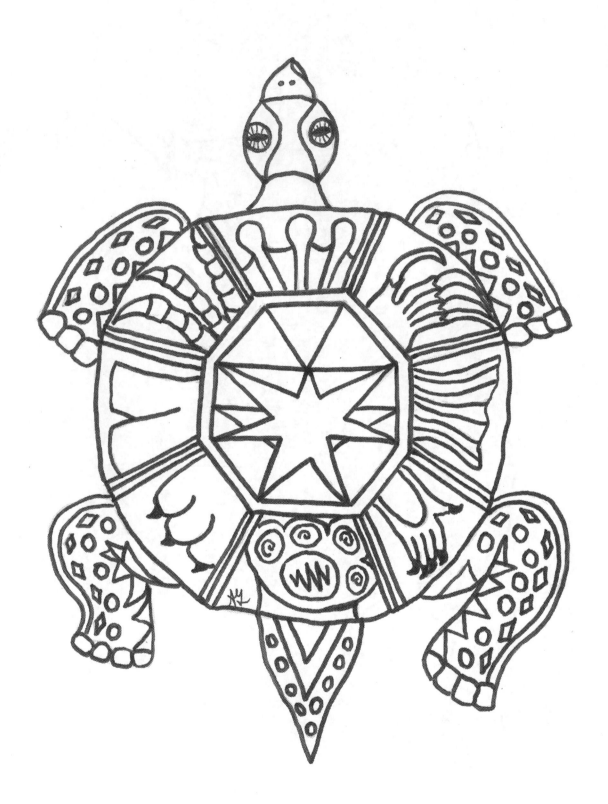

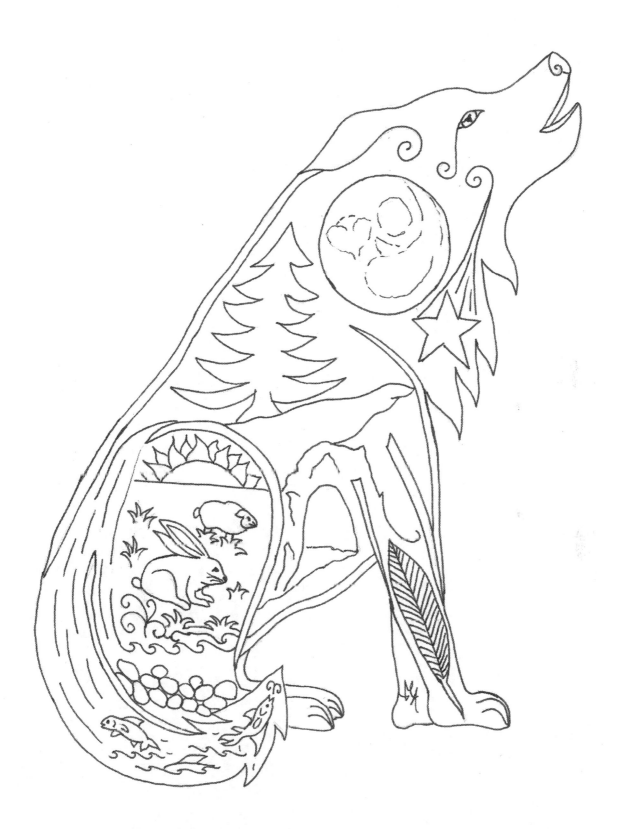